MEDITATIONS ON THE ICONS

Thomas Kala

MEDITATIONS ON THE ICONS

ST PAULS

Acknowledgements: The author gratefully acknowledges his indebtedness in writing this book to: John Baggley, *Doors of Perception,* Mowbray, 1987; Michel Quenot, *The Icon,* Mowbray, 1992; Leonid Ouspensky & Vladimir Lossky, *The Meaning of Icons,* Cassell/St Vladimir Seminary Press, 1989; Maria Giovanna Muzj, *Transfiguration,* St Paul Media Productions UK, 1991; Guillem Ramos-Puquí, *The Technique of Icon Painting,* Burns & Oates and Search Press, 1990; Maria Donadeo, *Icone di Cristo e di Santi, Le Icone, Icone della Madre di Dio,* and *Icone Mariane Russe,* Morcelliana, 1983, 1985, 1987, 1988; Jean Mathiot, *Icônes Surprenantes de la Mère de Dieu,* Médiaspaul, 1990; and the series of icon calendars published by "Centro Russia Ecumenica", Rome.

St Pauls
Middlegreen, Slough SL3 6BT, United Kingdom
Moyglare Road, Maynooth, Co. Kildare, Ireland

© St Pauls 1993

ISBN 085439 426 5

Produced in the EEC
Printed by Società San Paolo, Rome

St Pauls is an activity of the priests and brothers of the Society of St Paul who proclaim the Gospel through the media of social communication

Contents

Preface

This book aims to be no more than a humble contribution to the growing interest in icons especially as a means to prayer and meditation. For icons are the embodiment of a long tradition of meditation on the fundamental truths of the Christian faith. Defending the icon against the iconoclasts, the Church was not merely stressing its educational role or its aesthetic value. The Church was fighting for the very foundation of the faith, the visible testimony of God's incarnation as the basis of our salvation. 'I have seen,' wrote St John Damascene, 'the human image of God, and my soul is saved.' Such an understanding of the icon explains the steadfastness with which its defenders faced torture and death in the period of iconoclasm.[1]

The icons presented here for meditation have been chosen to illustrate the story of our redemption through the birth, death, resurrection and ascension of Jesus Christ. The important place which Mary the

Mother of Jesus occupies in this story is acknowledged by the in-clusion of three Marian icons. And the series is concluded, as befitting any prayer or invocation, with a meditation on the Trinity.

The section on meditations is preceded by short introductions to the history, painting, and meaning of icons in the hope that readers who are unfamiliar with the tradition of iconography may find them helpful. May all those who use this book or indeed any of the numerous icons in homes and churches be led to the true contemplation of God who transcends all things.

NOTE

1. ICONOCLASM: taken from the Greek word for image-breaking, it refers to a controversy that occurred in two stages and that disrupted the Eastern Church for more than a century. In 726, Emperor Leo III forbade the use of religious images and ordered them destroyed. The Empress Irene undid this policy in the early 780's, and the Second Council of Nicea (787) defined images as worthy of veneration and ordered them restored. In 814 iconoclasm broke out again under Emperor Leo V, but the movement finally ceased in 843 under the regency of Theodora. The precise origins of iconoclasm are somewhat obscure, but the struggle that it evoked aroused high passions. The theological justification for iconoclasm was basically that images were idols and that any representation of Christ in particular divided his humanity from his divinity. The fundamental theological justification for the veneration of images, on the other hand, which was well expressed, for instance, in St John Damascene's *First Apology against those who attack the Divine Images*, was that all matter – and hence images – had been ennobled by the Incarnation and was worthy of bearing representation of the holy and even of the divine.

1

The history of icons

THE word icon (from the Greek *eikon*) means image. Although sometimes hijacked by the worlds of art and fashion to denote a cult figure, the word still means in general religious paintings usually on wooden panels in the Byzantine style, which are mainly of either Greek or Russian origin, and have a prominent place in the life and worship of the Eastern Orthodox Churches. Icons may be large or small. Some smaller icons have hinged metal covers to enshrine and shield the painting. In the liturgy of the Eastern Churches icons play a more significant part than statues in the Roman rite. As it is believed that through them the saints exercise their beneficent powers, icons preside at all important events of human life and are held to be powerful channels of grace.

An ancient tradition describes the evangelist St Luke as the first icon painter. In fact, several early icons of the Virgin and Child are attributed to him. And later icons depict him at his easel, with an angel guiding his hand.

The origins of iconography are roughly contemporary with the historical period of the gospels. For the immediate forerunners of the first icons were the Fayum portraits, which are panel paintings that have

survived from the late Graeco-Roman period. Most of them were found at the settlement of Fayum at the mouth of the Nile Delta in Egypt. Little is known about the religion of the group who lived there between the first century BC and the third century AD. But their paintings are obviously derived from masks moulded in relief on mummy cases.

These portraits, which were approximately life-size heads, were naturalistically painted; but they had spiritually idealised youthful looks. They were done on thin wooden panels that were inserted, over the face of the deceased person, at the surface of the mummy case, sometimes complete with inscriptions to serve as identification. The Christians of Alexandria quite naturally adopted the local custom and placed similar encaustic panels in the tombs of their hermits and martyrs.

The earliest icons known to us come from St Catherine's Monastery on Mount Sinai and other places in Egypt. They date from the fifth and sixth centuries and are closely similar in style to the Fayum portraits. Although the content has changed from pagan mystery to Christian image, the technique is the same: wax encaustic. The colours, mostly from mineral sources, were held together in a medium of wax. Opinions vary on how the pigments were mixed in the medium and how they were applied to the picture surface. But what is certain is that the wax was hot and therefore molten while it was being worked.

Wax encaustic was the technique employed throughout the Christian world during the first

iconographic period which lasted for at least three hundred years until the iconoclast controversy in the eighth century.

With the next period of iconography came the technique of using egg instead of wax for binding the colours. Icon painting continued with the egg tempera method up until modern times and has never accepted oils as a medium.

For centuries icons were painted in workshops in the contemplative surroundings of monasteries. Different stages of the work were executed by members of the religious community working as a team, perpetuating the tradition of a particular school under the direction of a master.

The monks derived their inspiration from the strict traditions of the Byzantine Church for painting their icons, which were then blessed according to the Byzantine rite. Thus they became objects of special veneration for the believers. An icon does not become holy unless blessed by the Church, which confers on it the right to belong in the sanctuary. In the oriental liturgy icons are incensed, carried in procession and venerated by the faithful. In the homes too they have a special place.

We now return to the true setting in which the art of icon painting developed: the vast territory of the Byzantine empire, which was an extension of the Roman empire eastwards. Its capital Constantinople (modern Istanbul) was built in 330 on the ancient site of the Greek town Byzantium by the emperor Constantine, who had adopted Christianity as the state religion.

This was a time when Rome, Alexandria, Antioch and Ephesus were already well established as great cultural centres. These first centuries saw the evolution of an early Christian art form which used a language of symbols, Old Testament narrative and a Christian reinterpretation of pagan images.

Another significant factor in this period was the great spiritual energy generated by a succession of Church councils which debated and defined several important tenets of the Christian faith. We see, for example, the Council of Ephesus proclaiming the Virgin Mary as *Theotokos*, the Mother of God, who early in the seventh century became the patroness of Constantinople. This gave rise to a cult which became closely associated with the veneration of icons.

The enthusiasm for the veneration, and in some cases perhaps the worship, of icons finally sparked off the great iconoclast controversy, which agitated the Eastern Churches from 725 to 843. The iconoclasts, who had imperial protection, claimed that icons, were being given the worship due to God alone. This led to the official suppression of icons, which was opposed by the Second Council of Nicaea in 787. The Council affirmed that honour shown to statues and images was directed to the person represented and not to the image itself.

There was another outbreak of the iconoclastic controversy in 814 under the emperor Leo V, who removed icons from churches and public buildings. Persecution ended only with the death of emperor Theophilus in 842. His widow Theodora caused Methodius to be elected Patriarch of Constantinople

in 843 and on the First Sunday in Lent that year a feast was celebrated in honour of the icons. It is now known as the 'Triumph of Orthodoxy'.

The protracted iconoclast controversy reflected the conflict of the traditions of the Semitic and Islamic peoples with those of the Greeks who considered images vital to their culture. The main argument in defence of the icon was the *mandylion* (Veronica's veil), the true image impressed upon the cloth by Christ himself. This was the first icon, the prototype, painted without the aid of human hands. The mandylion has been the inspiration for the icons of the Holy Face of Christ, 'The Saviour Acheiropoietos: image made without hands'.

St John Damascene (675-749), who fought against the iconoclasts, taught that the icons tell us in pictures what the gospels tell us in words. Such teaching has a direct bearing on the consolidation of icons as visual theology and as an integral part of the liturgy. This 'Triumph of Orthodoxy' was to be celebrated in numerous icons as, for example, in the late fourteenth or early fifteenth century icons from Constantinople in the British Museum.

The mosaics of St Mark's in Venice as well as many in Sicily go back to the earlier period between the ninth and twelfth centuries covering the reign of the Macedonian and Commene dynasties in Byzantium, which saw a renewed fervour in religious art. Some icons were also preserved on Mount Athos and Sinai.

In the early thirteenth century, when Constantinople was invaded by the Venetians and the Crusad-

ers, we find a mixture of styles in the icons from the Holy Land. By the fourteenth and fifteenth centuries, icons in Constantinople show a high level of artistic accomplishment.

Byzantine influence also spread to Russia, culminating in the work of Andrei Rublev (c. 1360-1430). In its Council of One Hundred Chapters (1551) the Russian Orthodox Church held him up as an example for icon painters.

The fall of Constantinople to the Ottoman Turks in 1453 marked the end of the Byzantine empire, but the influence of its art lingered on. For many centuries Byzantine art had a considerable influence on sacred art in Europe, as seen for example in the works of Cimabue and Duccio. It was also the basis from which early Italian painting in Florence and Siena was to develop.

A prominent feature of any Byzantine Orthodox church is the wooden screen which displays the icons: the iconostasis. It separates the nave from the sanctuary and has a central door (known as the royal door) which carries an image of the Annunciation. The door is flanked by an icon of Christ and an icon of the Mother and Child. The first iconostasia were made of stone or marble and were quite low. Icons began to appear first on a wooden beam along the top in the eleventh and twelfth centuries. Later the whole screen became covered with icons. Being an essential element of the liturgy, icons also came to be placed on lecterns for veneration, especially on feast days.

Today the icon tradition is mainly carried on by

experts working alone through commissions from churches or individuals. They may revive prototypes dating back to the fourteenth or fifteenth century when icon painting was at the height of its artistic splendour, or they may work on a modern version of a traditional icon.

2

The painting of icons

THE painting of an icon is the opposite of subjective expression since it demands identification with a tradition. It is a discipline that needs dedication and humility. It was not uncommon for the great iconographers to undertake some fasting and spiritual exercise in preparation for their work.

The art of painting an icon requires a special style which is not a naturalistic imitation of life. It is visual theology or the holy scriptures in pictures. Hence the term iconographer: someone who *writes* rather than paints icons. This is why in churches icons are placed on lecterns. In fact, in iconography the drawing technique is similar to that of calligraphy. The image has to be shaped by means of subtle configurations and geometric patterns.

According to tenth century theologians, icon painting was a spiritualisation of matter, actually reflecting the Incarnation, the appearance of God on earth. Incorporated into this teaching were fragments of an ancient knowledge, elaborated by the neo-platonists, about the nature of matter and the substance and structure of the universe. Techniques of painting were developed in the light of such ideas, which prove that the great masters of icon painting had an understanding of the materials with

which they worked. These materials had combined in themselves both divine and earthly energies that influenced vegetable and mineral substances. To paint an icon was to bring about a transformation of matter, which is not only a perennial problem for philosophers and spiritual writers, but a crucial question for many Christians who have lost a sacramental vision of the world.

As mentioned in the previous chapter, wax encaustic was the first technique emplyed in icon painting. Then from the eighth century onwards egg instead of wax began to be used for binding the colours. Egg tempera, which is still used by today's icon painters, is a mixture of egg yolk and water. It is usually applied to a smooth, absorbent white gessoed panel of wood. The surface is generally known by the Italian word *gesso,* which means chalk. It is in fact made of finely ground chalk whiting, sometimes with marble and sometimes even alabaster ground into a fine powder; it is then mixed and applied to a wooden panel, which in turn is rubbed and burnished.

In wealthy institutions a layer of gold leaf would be laid on this gesso and burnished with an agate stone. The gold leaf would not be laid directly on to the gesso but on to a special preparation called bole made from red or yellow earth. Then the surface is protected with various glazes.

Byzantine artists developed special methods of building up the painting in layers, from cooler dark or medium tones to warmer and lighter tones. The technique differs from fresco and water colour.

Egg tempera painting is one of the most ancient techniques. Handed down from late antiquity, it was used on panels and gessoed grounds in Europe from Hellenistic times, and especially from the Middle Ages to the late fifteenth century. However, it was slowly replaced when artists began to experiment with other techniques from the fourteenth century onwards. Canvas, being lighter and more malleable, was preferred to wood. Artists were looking for media and grounds that would make the surface less absorbent so that alterations would be easier. They were searching for less linear, more fluid, and at times even impressionistic ways of handling paint on canvas. Eventually egg tempera was almost entirely replaced by oils.

Today many artists and art lovers have become fascinated by the beauty of the ancient technique of egg tempera used in old Byzantine icons. Their colours still glow with a life and luminosity that can never be achieved with oils. This is due to the stability of the egg tempera medium and to the luminous quality of the gesso ground.

There is something magical about the colours in old icons. They were of natural origin: earth or mineral, such as yellow ochre, terre verte, lapis lazuli; animal, such as carmine and crimson lake (made from the dyestuff of the cochineal beetle); vegetable, such as rose madder (made from the roots of a plant). To the unspoilt mediaeval eye colour was always a rare and precious commodity which, apart from flora and minerals produced by nature, could only be manufactured at great ex-

pense and with great labour and skill. Colour was not part of everyday life but an attribute of wealth and power, which were themselves attributes of religion and superior knowledge.

The knowledge associated with colour and techniques of art in the early Christian period was of a high order. It derived, as mentioned earlier, from the philosophical teachings of the neo-platonists who described the universe as irradiated with energy from the divine realm of which the symbol, in the physical world, was light. The breaking up of light into colour, its constituent elements, symbolised the principle of unity within multiplicity.

In the great centres of learning during the period up to the fifteenth century, Byzantine and Slav painters achieved a mastery over colour that not even the impressionists surpassed. Such theories as the 'law of complementary tones' were fully understood and the most dazzling and brilliant effects of colour were achieved from such materials as lapis lazuli, terre verte and the flaming vermillion made from mercuric sulphide. The suspension of such colours in the egg medium and laid over a gesso or gilt-gesso ground, allowed the light to pass through the materials and to be reflected into the eye in a series of events that are almost alchemical, demonstrating a transformation of matter, or rather of vibrations of light. The transformation of matter by the finer vibrations of light can be regarded as more than the ultimate symbol: it is a demonstration of the action of divine energy manifested on the physical plane.

Underlying the composition of an icon is a sub-

tle geometry of pure forms: curves (circle), verticals and horizontals (square), and diagonals (triangle). These are all interwoven into a harmonious whole. This is the language of sacred geometry.

The words in icons are an integral part of the design. Without the name of the holy person the icon remains incomplete. This is in keeping with some traditions of the East, where the written word is an essential part of visual language. The names or words in an icon are often abbreviated, divided up and freely distributed on either side of the figure. The style of the letters varies from one century to the next and in later periods becomes more ornamental. The Byzantine letters differ slightly from modern Greek.

The shapes created by folds in drapery enhance the gestures and meaning of the subject. Although they are represented in an abstracted geometric style, the folds are never arbitrary. They make logical sense, and where the garment touches the holy body it radiates energy and light.

Hands and fingers are far from naturalistic as they have a special symbolism in the Byzantine tradition. They either bless, pray or point to God. The faces in icons are not ordinary portraits, but depict the divine presence in the human being. Heads are never painted in profile since the word of God has to be received face to face. The top of the head approximates the form of a circle, the symbol of perfection, unity, totality, that which is holy, God. The eyebrows form a bridge across the top of the nose, and the eyes are carefully shaped to be in

harmony with the contours of the eye sockets. The line of the nose ridge ends in an oval tip and is continuous with the nostrils. The lower half of the ear is always uncovered as the figure is listening.

In a holy figure the five senses are symbolically depicted and interrelated. The ears listen to God's word, the nose senses its perfume, the mouth praises it, the hands point to its beauty, goodness and truth, and the eyes contemplate its mystery.

As an alternative to gilding, the background of some Byzantine icons were covered with a series of silver plaques. These plaques sometimes had minute figures in relief and were mounted with enamels, precious stones and pearls. Many icons show nail holes where these plaques have been removed. These ornamental designs are sometimes incorporated into the decoration of haloes and borders.

Perspective in icons is not bounded by rational conventions. Icons, like the works of Cubists, freely incorporate several viewpoints, challenging terrestrial laws by elevating perspective to a level higher than the third dimension. They are not subject to earthly laws of time, space and gravity. The icon shows a cosmic version of events seen in eternity and is therefore indifferent to the transcience of time. Space is conceived as a series of metaphoric levels into the world of the spirit.

A single composition can combine a variety of perspectives affecting its different elements: a linear converging perspective with several vanishing points; axonometric projection, where receding lines remain parallel and receding objects do not diminish

in scale; inverse perspective, where the vanishing point is the beholder; a curved horizon perspective, as in a concave mirror, where spirit endows matter with a new dimension, and buildings and objects bend towards the holy figure, representing a cosmic vision in which the universe is like a curved sphere, the centre of which is Christ; a view from above, as of God looking down; or a view from below as of the spectator looking heavenward; or a view from ground level as if the spectator were prostrate at the feet of the saint.

Buildings in Byzantine icons are colourful free interpretations, with elements taken from Greek architecture and late antique ornament. They are painted as backdrop and even if the scene takes place in an interior, the figures are shown in front of the building. To suggest the idea of enclosure, or an interior, a red cloth is painted hanging across the buildings. This is the veil which concealed the Holy of Holies in the Old Testament and which is now opened to reveal the Christian message to the world.

The intriguing mystical expression of some faces points to the possible use of several perspectives simultaneously to render the features. When the head is in three-quarter view, for example, the nose seems to be in profile, while the ear is seen in full. The nearside eye seems to be looking upwards, while the other is looking at us, although the amount of white underneath implies it is looking upwards. The mouth is almost frontal, while the chin is seen slightly from below.

These subtle changes of perspective in the face

are echoed in the body. All the shapes in the features are thus related to the shapes in the figure. The head is not meant to be viewed in isolation and when the icon is seen as a whole, these apparent distortions merge in total harmony. The illumination of the face radiates from within and it can hardly be rendered in a naturalistic manner.

Mountains and vegetation in icons, like architecture, are used as background props, and form part of a cosmic scheme. The human journey of ascent to the divine is symbolised by a series of metaphoric levels in the composition: the level of darkness, the earthly level and the divine level, where God is represented either symbolically as a circle or by Christ himself.

Mountains, where God's presence was manifested, are an ancient symbol. Their outlines, and the design of the light patterns on the slopes, are represented as if inclining towards the saint in respect, signifying that even created matter has been transformed by the holy presence. Trees and vegetation also acknowledge this presence by bending towards the saint, or thrusting forth towards the realm of the divine in joyous praise. In this art form all elements are affected by the subject matter and give meaning to it with simplicity, spiritual harmony and unity.

A common feature in icons is the symbol of the dark cave, the cosmos in darkness awaiting divine revelation. This is shown in icons of the Nativity, the Raising of Lazarus, St George and the Dragon, and Mount Calvary. Sometimes the cave is represented in

the form of dark windows or doors in the building.

In an icon with several figures, the overall composition falls naturally into geometric forms, the triangle, square and circle (corresponding to the numbers 3, 4 and 1). The ideas of Pythagoras and Plato on forms and numbers were reinterpreted in the Christian tradition, where geometric forms and numbers had symbolic meanings. Here the square represents the earth (with the four evangelists at the corners), the triangle the Trinity, and the circle the Divine Unity. The proportions of the panel are often 4:3 (height: width) giving a diagonal of 5. The simplicity of these numerical relationships was given symbolic significance. Another symbolic proportion, the 'Golden Section', which can be constructed geometrically from a pentagon, and which is found in nature, has been considered since classical times as the proportion of harmony. Christian artists have related the proportional relationships of the Golden Section to the mystery of God. Hence it is called the divine proportion.

The early icon painters did not consciously make geometrical diagrams. They were already trained to perceive harmony, order and proportion and work intuitively. An analysis of this sacred geometry helps us to understand how they used forms to convey the spiritual meaning of the icon.

Byzantine icon painting is governed by tradition and artistic convention. This tradition has, however, developed and changed over the centuries. Specialists are thus able to determine approximate dates, for icons are very rarely dated or signed.

Is it possible to paint a modern icon? Any attempt to modernise icons could also place them in a Western tradition. Nevertheless, an icon, like any other form of sacred art, may be painted today by an expert for a particular purpose or for the artist's own spiritual intention.

The Sienese painter Duccio reinterpreted and transformed the Eastern tradition in an Italianate-Byzantine style. His icon of the Transfiguration is now at the National Gallery in London. Under the mannerist influence of the late Renaissance and Baroque, the style of icons gradually changed into an eclectic art form far removed from the true Byzantine tradition.

Some people consider painting icons an uncreative anachronism. An icon is said to be a mirror of divine revelation. A painter's interpretation of it is also a reflection of his spiritual attitude. A good craftsman may make a competent copy, but the true artist tries with reverence to capture the spirit of the icon. All religious works of art are in some way related to the spirituality of the artists who create them. This is also true of icons and iconographers.

Dionysius of Fourna in his *Painter's Manual* tells his pupils that even at the stage of copying the works of others they must 'not carry out this work haphazardly, but with the fear of God and with the veneration due to a sacred task'.

3

The meaning
of icons

ICONOGRAPHY is a theological art consisting of both the vision and knowledge of God. Neither art nor theology taken separately could create an icon. For the icon is under a double obligation: it must be faithful to the visible world and also to God who cannot be reduced to representation. The icon is the result of a long tradition of meditation and elaboration of painting techniques, and has a rich theology of forms and colours, which is closely related to the other forms of theology. The themes of icons are determined by rules established by the Orthodox Church; they are therefore not open to intellectual speculation. The icon reveals the spiritual reality which is beyond all verbal expression.

In a world so wrapped up in itself the icon teaches openness towards the beyond as the secret of happiness and invites us to develop an interior vision. This explains why many icons use mountain tops as a symbol of closeness to God, and the door as a reminder of Christ and revelation.

Icons are not simply illustrations of biblical themes or stories. Just as the theologians who developed the interpretation of the scriptures saw in the written text many different levels of truth, so in approaching icons we must be aware of the different levels of truth in them.

Such levels are achieved and expressed through the symbolic language of colour and form. Many people comment on the oddness of the features in an icon. But icons are not intended to be naturalistic works of art. We must leave behind most of the assumptions of religious art and accept what we first find intuitively attractive about an icon. It is vital to see icons as expressions of the spirituality of the Orthodox Church and its interpretation of the relationship between God, society and Church.

While we meditate on the icons it is useful to bear in mind the neo-platonic view of the world with its different levels of being. These levels form the hidden agenda in many icons. They speak of the progress of the soul from the realm of the passions to a full union with God in stillness. In some icons the dark lower levels, or a cave in a corner, may be taken to represent the lowest levels of existence, while at the top a circle or a hand will represent the divine presence. Sometimes a ladder may stand for the spiritual ascent. The representation of saints on horseback denotes control of the passions. A diagonal movement may hint at the spiritual journey or else the incarnational movement of divine grace from the heavenly realm to the earthly level.

Just as most monastic traditions urge watchfulness and attentiveness, so also many icons convey a sense of stillness and inner recollection. This is partly achieved through the use of certain techniques in design which create a sense of poise, harmony and order. In icons of Christ in glory the figure of Christ is enclosed within a red diamond

shape, within the dark almond shape of the mandorla, which is enclosed by a rectangle; the whole composition is so centred that one cannot help being drawn into the harmony and balance of the icon of Christ in whom all things hold together.

Sometimes a strong triangular pattern lies within an icon, a hidden structure around which the whole composition is constructed. Or a circle is the unseen unifying structural factor that unites the various elements. Often there can be a profound sense of controlled energy held in creative tension, pointing to that inner work of prayer and purification to which we are called. Another technique which is often used in icons of individual saints is axial symmetry: the standing figure of the saint has a stability and inner balance that provide the focus around which the various details of the saint's life are assembled.

The use of inverse perspective, which places the converging point in the eye of the beholder, makes you feel essential to the completion of the icon. It establishes a communion between the event or persons represented in the icon and those who stand before it. This technique helps to fix attention on the icon by preventing the eyes from wandering beyond the figures represented. Other deliberate distortions of normal perspective are used to indicate that our everyday world is also the scene where events of an inner or higher world are taking place.

The techniques involved in the use of light and colour create a sense that we are looking into a world illuminated not by an external light that casts

shadows, but by the light of divine grace that transforms buildings and landscapes, and is particularly manifested in the inner illumination of the saints. In much Christian and neo-platonist philosophy there has been great stress on the role of light as a mediator between the world of matter and spirit. In some icons a ray of light from the top indicates a movement from the heavenly realm to the earth where particular events are happening.

The buildings represented in icons are perhaps the most obvious non-naturalistic elements. They help to show that a particular event and its significance are not confined to a precise historical moment, but belong to the world of the spirit. The wider significance has to be worked out in the soul of the beholder. It is therefore our own inner world that is being addressed.

Two other details of the surroundings that are common in icons are trees and mountain peaks. In scripture reference is made to the tree of knowledge of good and evil (Genesis) and the tree of life that stands near the river of water of life and bears leaves for the healing of nations (Apocalypse). In icons the tree is a symbol of life and spiritual growth, while the mountain peak represents an event of profound spiritual significance. Often these symbols are much distorted as if to reinforce their symbolic function.

In the representation of the human body there is a similar range of distortions. They are used consistently to denote the dematerialised, spiritual form of the subject transfigured by divine grace. The essence of what is being communicated in icons of the

saints, for example, is their participation in the divine life: their faces are turned towards the beholder. The face and head may be disproportionately large in relation to the rest of the body, and the eyes and ears enlarged, while the mouth may be very small and the lips tightly closed, thus conveying a sense of inner watchfulness and attention; and the eyes are often inward looking, turned away from the world of the senses.

The gesture of the hands in an icon can be very eloquent. Sometimes the simple gesture of pointing can draw attention to the person or mystery that is at the heart of an icon. In icons of the Mother of God Hodigitria (she who points the way), one hand of the Virgin forms a throne for the Son while the other hand directs our attention to the Incarnate Son who is the Way, the Truth and the Life. The hand raised in blessing is often close to the heart of the person represented, and is usually turned inward towards the heart rather than outward towards the external world. Here again by a symbol and gesture we are led to the spirituality of a tradition where the name of Jesus is closely linked with the prayer of the heart. Icons are thus a means of entering into the stillness of heart where God can be known and loved.

Other stylistic techniques draw attention to the interior work of prayer and attentiveness that form the route to the transfigured life. The human form may be shown rather like a silhouette, definitely bounded by a restraining outline. We are led by such means to concentrate on the person of Christ

or the saint as one who embodies the life of the world to come. Often the line of the silhouetted body will be broken by the tip of a pen, the edge of a book or scroll, or by a wide-open hand in a gesture of self-giving. Sometimes the figure of Christ or the saint will extend beyond the main surface of the icon on to the outer frame. These subtle details are part of the silent language of icons that open for us a window onto eternity.

4

Meditations on the icons

The Annunciation

The proclamation at the Council of Ephesus of Mary as *Theotokos,* the Mother of God, resulted in the true flowering of Marian devotion in the East. The sixth century saw the institution of various feasts to honour the Mother of God: the Nativity of Our Lady, the Annunciation, the Presentation of the Lord, and the Dormition. A century later two more feasts were instituted: the Conception and the Presentation of Mary. Her Immaculate Conception was proclaimed a dogma in the last century, and in our own century the Assumption of Mary into heaven also became a dogma. Doctrine and liturgy have thus established the closest possible analogy between the Mother and her Son.

The fifteenth century original, from which the present reproduction was made, is in the Tretiakov Gallery in Moscow. The scene is dynamic both in colour and movement. The angel's posture and gesture contrast with the figure of the Virgin who is in deep recollection. Her head and hands indicate that she is at God's disposal. The red curtain in the background places the scene in an interior and is also perhaps an allusion to apocryphal texts which

talk about the Virgin staying at the Temple in Jerusalem and together with her companions weaving the veil for the Holy of Holies, which prefigured the humanity that the Mother would 'weave' for her Son.

The Slavic title of the icon *Blagovescenie* means Good News. The icon narrates the story told in Luke 1:26-38 and commemorates the corresponding feast on March 25, and invites us to meditate on this momentous event.

The Annunciation is the beginning of the story of our salvation. It is the best news humanity has ever had. Its joy and excitement spill out to us from the icon. The colours, the festive air of details, and the posture of the Archangel Gabriel proclaim the joy of the Incarnation.

'Hail, full of grace,' the angel greets the Virgin. 'The Lord is with you. You are blessed among women, and blessed is the fruit of your womb, Jesus.'

The legs of the angel set wide apart retain the sense of his journey from God to the Virgin Mary. The staff in his left hand symbolises his role of messenger. His right hand, stretched towards the Virgin, communicates the Good News of God's decision to dwell among us in the flesh.

In contrast to the bright and festive outer aspect of the icon, the inner significance of this decisive moment in the history of humanity is conveyed with great restraint in the posture and the barely noticeable gestures of the Mother of God.

'How is this possible?' asks Mary. She is prudent and naturally bewildered at the angel's amazing

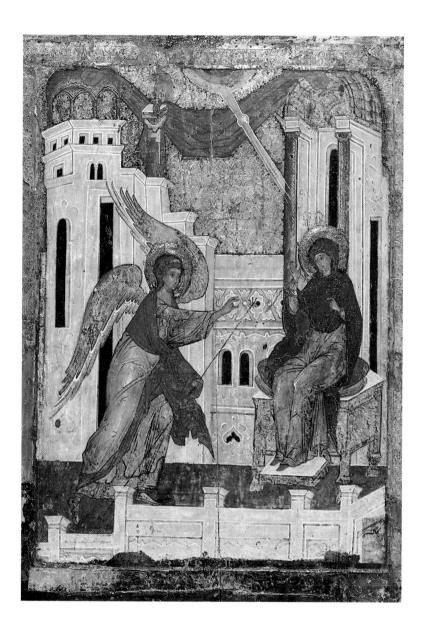

The Nativity of Christ

The composition of icons of the Nativity of Our Lord goes back to the first centuries of the Christian era. The Phials of Monza (4th-5th century), whose provenance is traced to the Holy Land, already had a similar painting on them.

In the icon reproduced here, the abbreviated Slavonic inscription stands for the 'Birth of Lord Jesus Christ'. In the East the feast of December 25 celebrates the whole mystery of the coming of the Son of God into the world and includes also the visit of the Magi and several other details. This explains the surprising richness of the present icon of the Nativity, in which events distinct from one another in time and space, as well as symbolic figures, are portrayed to illustrate the different aspects of the mystery of God who assumed human nature and dwelt among us.

The icon places us before a visible testimony of the fundamental dogma of the Christian faith, emphasising through its details both the divinity and humanity of Jesus. It further shows us the effect of this event on the natural world, for Christ came to redeem the whole world. Thus we see represented round the Child the whole created world.

At the centre of the icon, in a manger at the mouth of a dark cave we find the new-born Child, 'the light that shines in the darkness'. The dark cave is the symbol of a world in need of redemption and transformation, while the swaddling clothes of the Child are the walls of the tomb from which will

come forth the Risen Saviour. A ray of light, like the One God on high, emanating from the star, becomes triple, in evident allusion to the Trinity, and descends on the Mother and Child.

The manger is seen as the offering of the wilderness to the Divine Child. The wilderness has Old and New Testament associations. He who had rained manna (bread from heaven) for his people in the desert has now himself become the bread of the Eucharist. The manger becomes an altar for the sacrifice of the Lamb who takes away the sins of the world. And to this altar are invited the Jews (represented by the ox) and the Gentiles (represented by the ass), according to an interpretation of the early Fathers. The gospels do not mention the ox and the ass. Yet pictures of the Nativity rarely leave them out. Their presence in the centre of the icon stresses the importance given by the Church to the fulfilment of the prophecy of Isaiah (1:3): 'The ox knows his owner, and the ass his master's crib: but Israel does not know me, and the people have not regarded me.' By reminding us of this prophecy, the icon calls us to meditate on the mystery of the Incarnation and understand its far reaching significance in our lives.

Above, on the left, two angels are in adoration while another angel, on the right, announces the good news to the shepherds. The three wise men, on horseback, are guided by the star to the Saviour. The shepherds are simple, unsophisticated men who are given direct communication of the birth of Jesus. The wise men, scholars and researchers, however, have to undertake on arduous journey from

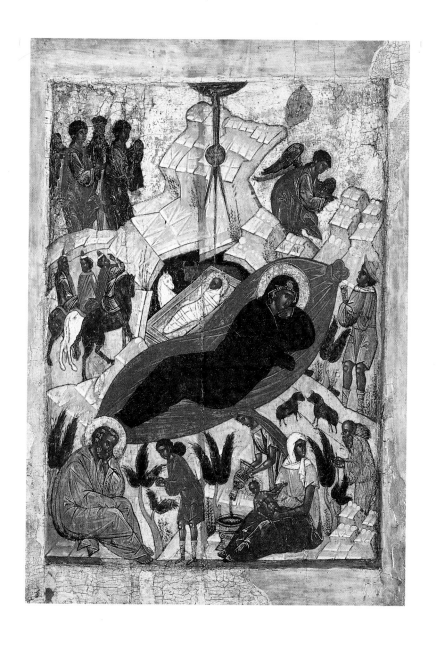

what is relative to the knowledge of what is absolute.

Between the wise men and the shepherds, St Joseph is seen in a pensive mood. He is facing a temptation, for the devil in the guise of a shepherd is insinuating doubts about the virginity of Mary. This argument, assuming different forms, keeps reappearing through the history of the Church, and is the basis of many heresies. The icon points not only to Joseph's personal difficulty, but to the drama of all humanity – the difficulty of accepting the Incarnation of God.

In the bottom left corner the Child is being bathed. This scene is based on tradition and some apocryphal gospels. It affirms that Jesus has a true human nature and at the same time hints at baptism because the basin is in the shape of a baptismal font.

The central figure of the icon is the Mother of God. After giving birth to the Son, she lies on a purple cloth facing us, as if meditating in her heart the mystery of salvation in which she, the flower of humanity, has represented all of us by giving her consent to the Incarnation and has thus become our mother too. Clearly visible are the stars on her head and shoulders to remind us that she remained a virgin before, during and after the birth of her Son because of his divinity, which was denied by Nestorius and his followers.

The icon of Christ's Nativity, however, depicts the Mother of God in a posture of great lassitude to remind us also of the undoubtedly human nature of Jesus and his birth so that the Incarnation would not be dismissed as an illusion.

The Vladimir Mother of God

Brought from Constantinople via Kiev to Vladimir in 1155, this icon is the Marian image most loved by the Russians, whose history has been watched over by it for centuries. It has been in Moscow since 1395 – in the Cathedral of the Assumption till 1930, and since then in the Tretiakov Gallery. The feast of the Vladimir Mother of God is celebrated on May 21, June 23 and August 26 to commemorate three dates connected with the deliverance of Moscow from the Tartars.

The painting has been restored several times, but the section of the two faces is the oldest. Its beauty connotes a profound spirituality: the gaze of the Mother is charged with celestial majesty, and the Son, although in the guise of a child, is obviously the Word made flesh. He is represented with a lively and tender movement. He presses his face to his Mother's cheek as if trying to calm her hidden grief. But the Virgin's eyes are turned towards us. There is sadness in them.

Every human feeling expressed in an icon becomes transfigured, and here the thoughts of the Mother of God are already focusing on the future suffering of her Son. This compassion she feels for him is transformed into motherly tenderness for all creatures because their redemption is bought with her Son's blood. Her personal grief encompasses the universal grief, the tears in the heart of things, because suffering is an inalienable element of the world's order.

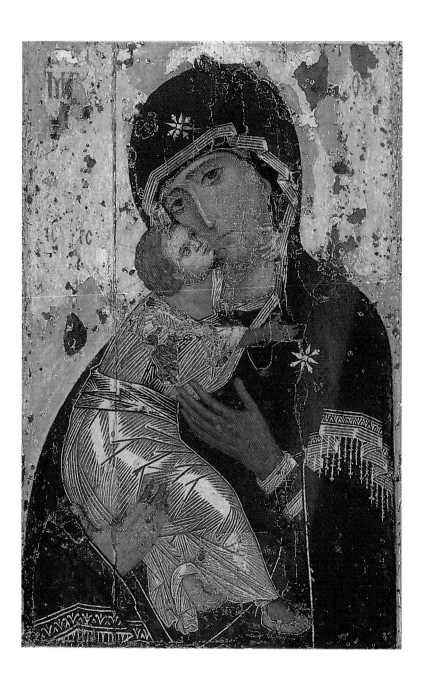

Paradoxically, the all-embracing grief of the Mother of God is also the reason why she is greeted as the joy of the world, the world's first love, which finds its fullest expression in the image of the Mother weeping at the foot of the cross.

Mother of God of Tichvin

This is one of the many iconographic variations of the Mother of God Hodigitria, 'she who shows the way'. Following the victory over the iconoclasts in 843, icons of the Hodigitria were widely diffused. It reflected the popularity of the devotion to the Mother of God in public and in private. The distinctive name Hodigitria derives from a church in Constantinople (Hodigôn, 'of the guides'), where an image of this type was venerated as the work of St Luke. Later the reference to the 'guides' came to be interpreted as 'she who shows the way'.

Tradition insists that the icon of the Mother of God Tichvin was carried by angels in 1383 from Constantinople to the banks of the Tichvinka river in Novgorod. Tichvin's liberation from the invading Swedish army on 26 June 1613 was attributed to the intercession of the Mother of God Hodigitria. To this day on June 26 the Feast of the Mother of God of Tichvin is celebrated with great enthusiasm and festivities. The icon we are meditating on, which is one of the many reproductions of an older icon, comes from the monastery of the Trinity of St Sergius.

As 'she who shows the way', the Virgin holds the Son in her left arm while with her right hand she points to him, who is the light that enlightens the world. The icon imparts a sense of solemn majesty, accentuated by the positioning of the two faces. The Mother is not looking at the Child but at the one standing in prayer before the icon. The Child is not a weak little creature but a strong youth presented by

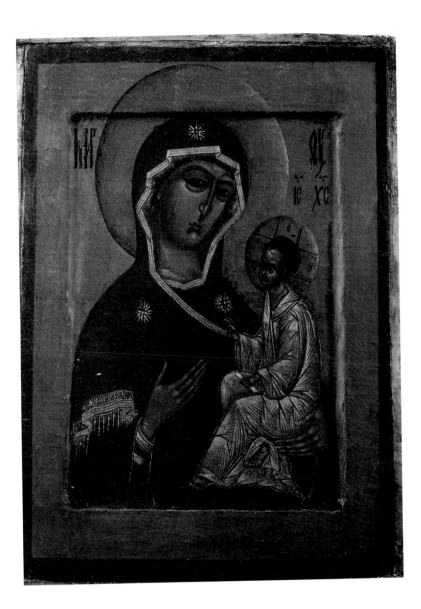

his Mother to humanity as Lord of the universe, Pantocrator. He holds himself straight, the right hand raised in blessing and the left holding the scroll of scripture. The gesture of the Mother of God inviting us to adore the Saviour is full of tenderness and love.

The Baptism of Christ

This icon was painted in the Russian monastery in Rome a few years ago. It measures 23 x 32 cm and is placed on a lectern in the centre of the church for public veneration from January 5 to 14.

The Baptism of Christ is also known as the Theophany of Christ as it was a manifestation of the Saviour at the beginning of his public life. When Jesus stepped into the River Jordan for his baptism, the Father acclaimed him as his Son: 'This is my beloved Son, in whom I am well pleased' (Matthew 3:17). And the Holy Spirit appeared in the form of a dove. This was the first public statement of the dogma of the Trinity.

If the icon of the Nativity is about the mystery of our redemption unfolding in time, the icon of the Baptism of Christ is a meditation on the same mystery in its eternal beginnings. It is a commentary on the theology of redemption.

The Son's obedience to the Father's will is the cornerstone of our salvation. When Jesus asked John to baptise him he humbled himself; but the Father exalted him. This is illustrated in the icon where the central figure of Christ dominates the scene. The effect is heightened by the figure of John the Baptist bending very low: 'I am not worthy to untie the straps of your sandals and do you ask me to baptise you?' Then Jesus voluntarily descended into the waters of death, and the heavens opened. This feast is indeed the celebration of the beginning of the new creation. From now on water

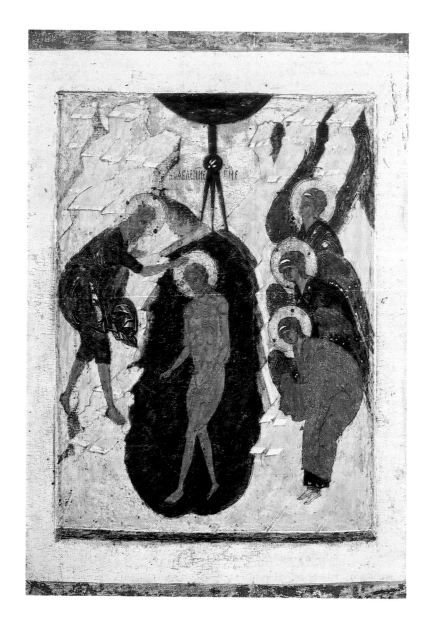

becomes the image not of death but of birth into a new life.

The pronounced vertical composition of the icon suggests the descent of God and the ascent of humanity. The Jordan appears in a narrow gorge between the harsh mountains. Into this watery tomb Christ descends in serene power and majesty. The widening cavern at his feet is a reminder of hell from which the risen Lord will free our first parents. Christ's descent into the waters prefigures the ultimate defeat of the powers of evil and the triumph of truth.

The heavens open and the divine ray reaches into the space between the mountains. In the ray the Spirit is depicted as a dove directly above the head of the Son. Along this vertical line is manifested the mystery of the Holy Trinity in its eternal order, uniting heaven and earth and effecting our salvation: from the Father, by means of the Son, in the Holy Spirit.

Angels, whose hands are covered by their own cloaks as a sign of reverence, are present at this incomprehensible humiliation of the Incarnate Word. John the Baptist performs the action at Jesus' insistence. The axe laid to the root of the tree signals the last days. If you wish to enter the kingdom of heaven follow the Son in whom the Father is well pleased: 'Listen to him!'

The Transfiguration

The feast of the Transfiguration is an important date in the Church's calendar. In the Eastern Church the feast was celebrated from very early times, while in the West it was introduced in the fifteenth century.

The accounts in the synoptic gospels and the Second Letter of Peter are presented in this icon from the school of Novogorod in a style that has been hallowed by tradition. The centre is dominated by the figure of Christ in white with rays of light radiating in a circle, which is the symbol of eternity. There is a predominance of warm colours ranging from yellow-ochre to red. The figure of Christ rises from the peak in the centre while Moses and Elijah on Christ's left and right point to him.

Below, the disciples are depicted as terror-stricken. On the right Peter seems to pluck up enough courage to look at the transformed figure of his Master while James and John lying prostrate on the ground cover their eyes. Their human terror in the face of this divine phenomenon serves to emphasise the peace and serenity of the figure of Christ.

The fullness of life, manifested as light radiating from Christ, does not remain enclosed in itself but includes all creation. This encounter takes place on the mountain, symbolic meeting place of heaven and earth. Christ on the mountain peak is the mediator between God and humanity; Christ is the Alpha and Omega, the beginning and end of all creation.

The divine glory of Christ was manifested to the

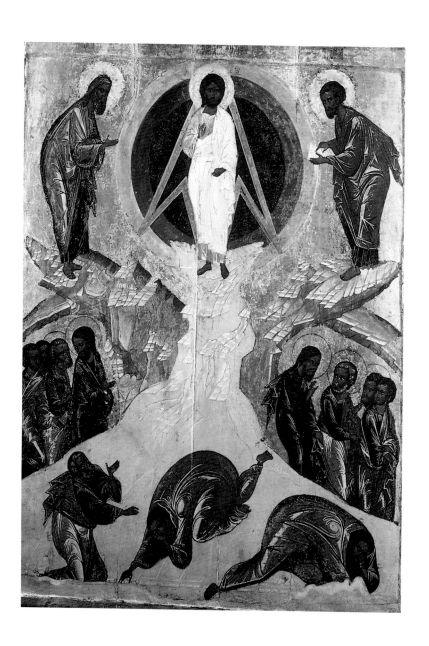

The Crucifixion

In this icon by a Russian painter of the sixteenth century, we see the body of Christ flexed towards the right, the head bowed and eyes closed. This is to show that the crucified Lord is dead. But his face is turned towards his mother, and there is an expression of majesty in suffering. The body of the God-man remains incorruptible in death to show the perfect harmony between the divine and human natures in the single person of Christ.

Victory over death and hell is symbolised by a cavern at the foot of the cross, below Golgotha, the rock that was rent at the moment of Christ's death, to allow a skull to appear. It is the skull of Adam who, according to tradition, was buried there, 'the place of skull'. This apocryphal story has a neat dogmatic point which the icon of the Crucifixion illustrates: the first Adam is redeemed by the blood of Christ, the new Adam. This redemption extends to the entire universe and finds its fullest symbolism in the three dimensions of the cross depicted in the icon. The transverse arm and the footboard represent the fourfold extension of the earthly space; the vertical axis points to the life-giving meeting between heaven and earth. The cross of Christ embraces the whole world and brings forth a new creation.

The architecture behind the cross represents the wall of Jerusalem. Besides corresponding to historical truth, this detail imparts a spiritual precept: as Christ suffered outside the walls of Jerusalem, so

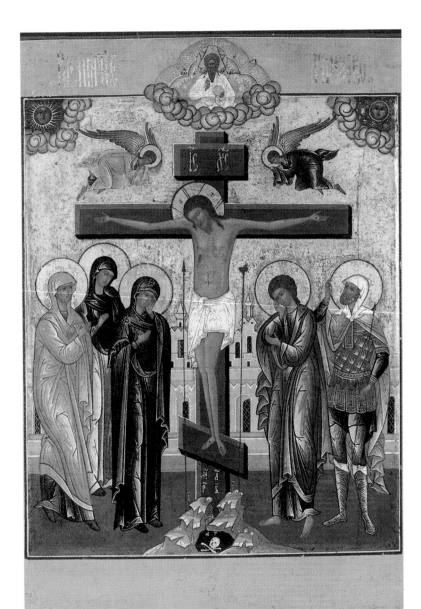

Christians must follow Christ by leaving behind the security of home, country, and the world itself. The upper part of the cross rises above the wall against the sky as background, denoting that the crucifixion in the open space has a cosmic significance – the redemption of the entire universe.

The composition of the icon is balanced and sober, the gestures of the figures restrained and grave, and the expression of grief on the Mother's face contained by faith. The Mother of God seems to be exhorting St John to join her in contemplating the mystery of salvation wrought by the death of her Son. There is a kind of religious terror in the expression of St John, who holds out his left hand towards the cross while with his right he seems to try to cover his eyes before the death of Jesus. The holy woman behind Mary has her features contracted with grief, her left hand supporting her cheek in a gesture of lamentation. The centurion behind St John looks at Jesus on the cross acknowledging his divinity, his fingers bent in a ritual gesture of benediction.

The Resurrection

The morning office of Holy Saturday says: 'O Lord, you came down to earth to save Adam and not finding him on earth you descended into hell in search of him.'

The iconographic composition of the Resurrection in fact shows us the descent of Christ into hell. Sometimes the Resurrection is portrayed, but it is rare. About the actual moment of the Resurrection the icons are mostly silent. Representations of a white clad Christ emerging from the tomb are of a later date and are the result of Western influence.

The present icon is faithful to the model fixed for centuries. Being a Russian icon, it contains not only the usual Greek letters to designate Christ but also the Slavic inscription in red to designate its name: Resurrection of Our Lord Jesus Christ. The centre is occupied by the Saviour in a circle (symbol of divinity) whose dark intensity becomes lighter towards the periphery. The white of the tunic and mantle of Christ recalls the colour noted by the evangelists at the Transfiguration of the Lord: it is an enfoldment of light, attribute of the glorified body and symbol of divine glory. In his left hand Jesus holds a cross, the sign of his victory, and with his right hand he rescues from the nether regions Adam, who symbolises all humanity. Behind the protoparent are David and Solomon, John the Baptist and the prophet Daniel. To the left of Christ is featured Eve who, with hands respectfully covered in the folds of her dress, awaits her turn to be

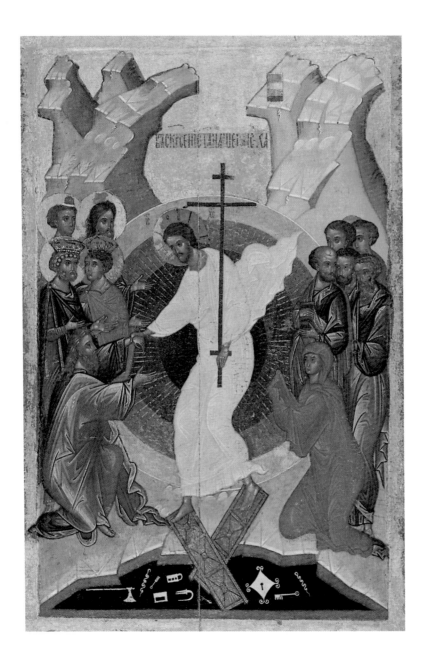

freed. Behind her are other just men of the Old Testament.

In the West the descent into hell, although included in the Creed, has not been a frequent subject in the arts, but it occupies an important place in the liturgical and iconographic traditions of the Byzantine East. It is the culminating point which St Paul (Ephesians 4:8-10) links with Christ's ascent on high to lead a host of captives. 'On earth,' says Paul Eudokimov in his *The Art of the Icon,* 'Good Friday is a day of sorrow, burial and the tears of the Mother of God; but in hell Good Friday is already Easter, the power of Christ dispelling the darkness at the very centre of the reign of death.'

Below the feet of Christ we find nails, keys, padlocks and the panels of a door that has been forced open. These are the sings of Christ's victory over suffering and death. The whole icon is symbolic and underlines the bodily Resurrection of the Redeemer.

In the higher part of the icon bare rocks stand for the aridity of our earth which, however, is touched by the power and radiance of the Resurrection. The background is gold to evoke light signifying divine glory. The whole composition possesses great harmony both in design and colour and will imprint itself on the hearts and minds of the faithful who for forty days will have the opportunity to see and venerate it when it will be exposed in the centre of the church from Easter till the Ascension.

The Ascension

The Ascension is the feast of the culmination of our salvation. At first glance Orthodox icons of this feast do not give the impression that they correspond to their name. The centre stage is occupied by the Mother of God, angels and apostles. Yet a study of the accounts of the event in the gospels and Acts shows that the emphasis is not so much on the Ascension as on its significance for the Church and the world. Orthodox iconography has remained faithful to the same emphasis.

According to Acts 1:12 the Ascension of Christ took place on the Mount of Olives. In the icon reproduced here the action takes place on the summit of the mount. The Saviour himself is depicted as ascending in glory represented in the round mandorla, composed of concentric circles, the symbol of the high heavens. This symbolism invests the moment of the Ascension with a character that takes it outside the narrow limits of an historical event. The mandorla is supported by two angels, an artistic device to express Christ's glory and power, while the two angels in the foreground behind the Mother of God are messengers of Divine Providence.

The presence of the Mother of God at the Lord's Ascension, although not directly mentioned in the scriptures, is affirmed by tradition and liturgy. Placed directly below the ascending Christ, she is the axis of the whole composition. Her pure, light and precise outline stands out sharply from the background of the white garments of the angels and is in stark

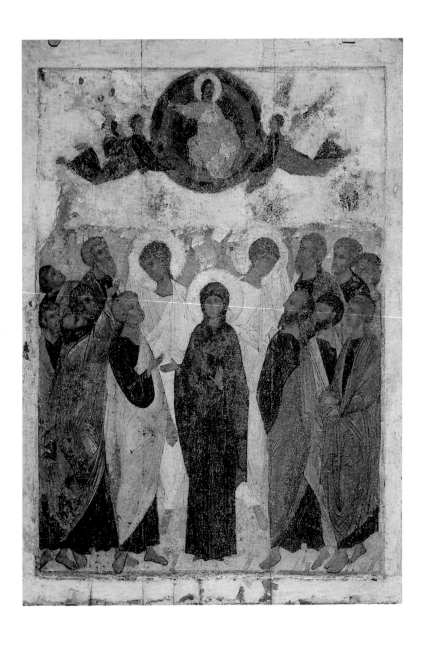

contrast to the animated figures of the apostles. This group, with the Mother of God at the centre, represents Jesus' legacy, the Church he was physically leaving behind, which through the promised coming of the Holy Spirit was to receive the fullness of being at Pentecost. The place of this group in the foreground of the icon is meant to give prominence to the idea and reality of the Church, which is shown in its full complement by the inclusion of the apostle Paul (at the head of the group on the left) who could not have been there historically and also by the presence of the Mother of God. Mary's raised hands in a gesture of prayer confirm her role and that of the Church as mediators for humanity. While her stillness symbolises the unchanging nature of revealed truth, the animation of the apostles and the diversity of their gestures express the variety of tongues and means for communicating that truth.

Christ who is ascending does not abandon the world and the Church. 'I will be with you always, to the end of time' (Matthew 28:20). The presence of Christ is real at any given moment in the history of the Church and in the life of its individual members. The icon expresses this connection by depicting Christ in the act of blessing the group in the foreground even as he ascends. 'While be blessed them, he departed from them and was taken up into heaven' (Luke 24:51).

This icon of the Ascension is also a prophetic icon. For the two angels standing behind the Mother of God and pointing towards Jesus announce the Second Coming of Christ in glory.

Christ Pantocrator

This seventeenth century icon from the Moscow school shows how the icon has remained true to itself through changing times and styles.

The first images of Christ date from the third century and were found in the catacombs of Rome. Fifth century mosaics at Ravenna portray him as a beardless Apollo figure, although some late fourth century mosaics in Rome already depict him with a beard. From the sixth century onwards he is always shown bearded and with the same features, as the majestic and solemn Pantocrator, 'the one who holds all things in being'. He wears Greek clothing and holds a jewelled book, either open or closed, while blessing with his right hand.

Who is Jesus Christ? This is the central question of Christianity. The Church gives its answer by means of the early councils, digging deep into the mystery of the Trinity and defining the divine and human natures in the single person of Christ.

The icon of the Pantocrator expresses in every respect the manifestation of the transcendent God who assumes human features. Christ appears as the creator of all that exists, together with the Father and the Holy Spirit, as St Paul says: 'He is the image of the invisible God, begotten before all created things; for through him all things have been created in heaven and on earth' (Colossians 1:15-16).

Without in any way minimising Christ's majesty, what is stressed in this icon is the tenderness and inexhaustible mercy evinced in the facial expres-

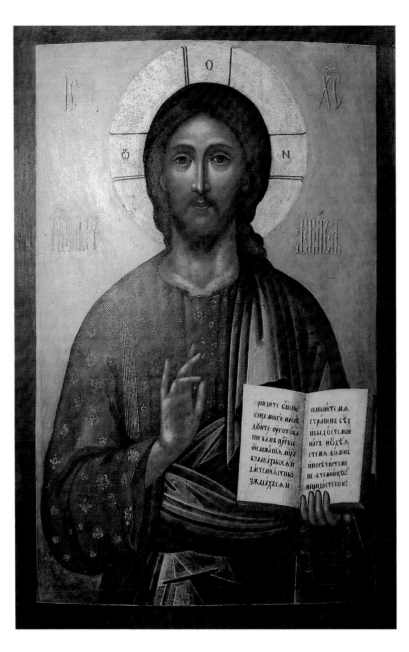

sion: Christ is the Lord who sustains all things and is the prototype of transfigured humanity. In the icon we find a Christ with a sorrowful and impassioned love for humanity. This love moves him to lay down his life for us so that we can share in the life of God. This is the fundamental message of the icon.

The open gospel quotes the words of the Day of Judgement: 'Come, you that are blessed by my Father. Inherit the kingdom prepared for you from the creation of the world. For I was hungry and you gave me food; I was thirsty and you gave me drink; I was a stranger and you made me welcome; naked and you clothed me, sick and you visited me, in prison and you came to see me' (Matthew 25:34-36).

Mercy therefore will be the measuring rod with which each person will be measured, since we are called to be perfect as the heavenly Father is perfect and to bring to completion the icon of Christ that has been engraved in each from the beginning.

The Trinity

The doctrine of the Trinity, the central dogma of the Christian faith, teaches that the One God exists in Three Persons (Father, Son and Holy Spirit) and one substance. It is a mystery in the strict sense and cannot be grasped by reason unaided by revelation. But the concept of the Trinity is not incompatible with the principles of rational thought. At the councils of Nicaea (325) and Constantinople (381) the distinction, equality, and co-eternity of the Three Persons were defined.

The Trinity is foreshadowed in the Old Testament as a mystery ready for disclosure. God deals historically with the fathers and the prophets. And the New Testament records the first clear manifestation of the Trinity, which was at the Baptism of Christ. It is above all through the Word and in the Spirit that God reveals himself to humanity. With the self-communication of God in Jesus Christ and in the Spirit in history, the revelation of the Trinity became rationally acceptable within our historical experience.

The event described in Genesis 18:1-5 where Abraham is visited by three angels at the oak of Mamre has always been interpreted in the East as a prefiguration of God in Three Persons. The text in fact interchanges the singular and the plural as if there were only one visitor.

The present icon, painted by the Russian monk Andrei Rublev in the first quarter of the fifteenth century, is full of symbolism. Whereas an earlier

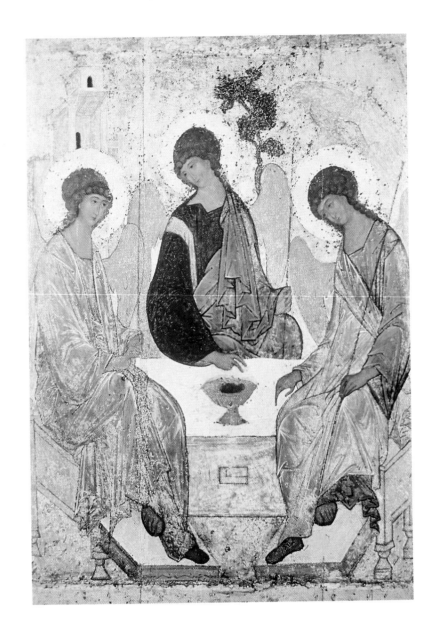

icon of the same theme (sixth century, San Vitale, Ravenna) portrays the entire scene, including Abraham, Sarah and the calf, Rublev's icon shows only Abraham's house, the oak and a mountain. It also substitutes the calf with the Eucharistic cup and groups together the angels in a triune council.

The icon measures 114 x 142 cm and was commissioned by St Nikon, the successor of St Sergius, at the monastery named after him, some sixty kilometres from Moscow. The icon was placed beside the remains of St Sergius, who was noted for his special devotion to the Trinity. Is is now in the Tretiakov Gallery in Moscow.

It is difficult to think of a comparable icon so rich in theology, symbolism and beauty. The very colours possess an extraordinary luminosity and transparence, creating within the circular movement of the scene a sense of profound peace.

A circle can easily be described along the outer contours of the angels on either side. In this composition of exceptional harmony a triangle and a cross can also be traced. What strikes us about the three distinct figures of the angels is not only their resemblance to each other but also their inherent unity: One God in Three Persons who complete one another in an endless circle of loving communion. The centre of the perfect circle outlined by the three figures is the chalice which signifies the sacrament of the Eucharist and the mystery of the Incarnation. God's eternal colloquy has as its subject the redemption of humanity.

Gateway to the Trinity

by Tony Castle

God is revealed not only by words to the ears but by images to the eyes as well. Christ is not just the world (Logos) of God but also the "image (eikon) of the unseen God". This is why the Icon is considered to be a window opening on the Divine. The Fathers at the Council of Nicea in 787 placed Icons on the same level of dignity as the Scripture and the Cross, as one of the forms of revelation and knowledge of God.

This book, written in the setting of an animated family of four vivacious children, is a "lay" catechesis of the Trinity, the family of God, keeping in prospect the Icon of Rublev, "the Hospitality of Abraham".

Tony Castle is a freelance writer, author of several books and editor of many publications.

ISBN 085439 273 4 £3.25 94pp